Art of Coloring

100 IMAGES TO INSPIRE
CREATIVITY AND RELAXATION

For information address Disney Editions,
1101 Flower Street, Glendale, California 91201

4th printing
Printed in China
FAC-005376-16217

First United States English Edition, November 2015
5 7 9 10 8 6 4

ISBN 978-1-4847-5738-3

STAR WARS
Art of Coloring

Coloring taps into the pysche of those who practice it. It stands to reason then that even the Masters of the Jedi Order must have devoted themselves to the holy practice, from the leaders of the temple on Coruscant to those residing in the depths of the muddy backwaters on Dagobah.

In our part of the galaxy, nearer our time, the psychologist and psychiatrist Carl Gustav Jung, deeply depressed for some thirteen years, recorded his dreams and his anxieties as tales and colorings in what is now considered to be an essential work of modern psychology, *The Red Book*. By coloring mandalas and monsters, and by using color to capture his anxieties and his dreams, Jung was reinterpreting his vast knowledge of human mythology in order to rediscover the way of reaching tranquility, of attaining an essential mental balance.

Incidentally, this is where Jung and *Star Wars* meet again: both have in their own ways blended heroic tales and mythology to offer hope and to define a way to produce something that enables us to find ourselves. What could be more obvious than to offer this "therapeutic" coloring based on the most famous contemporary pop mythology of them all?

So relax, turn the page, and, to paraphrase Yoda: "May the *coloring* force be with you."

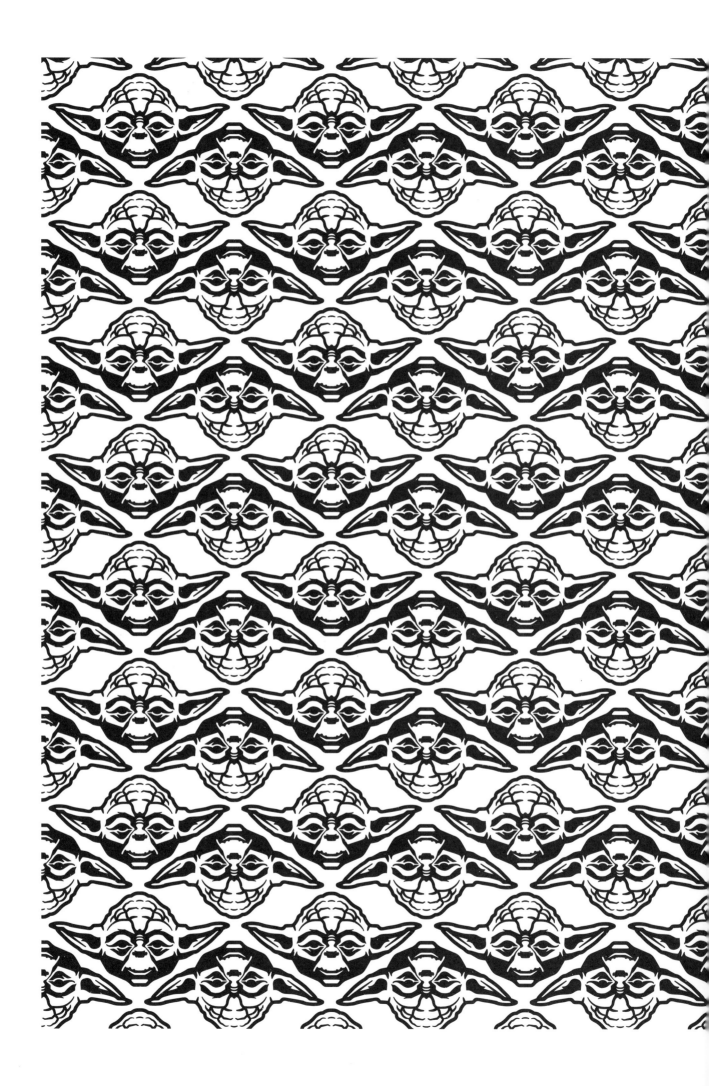

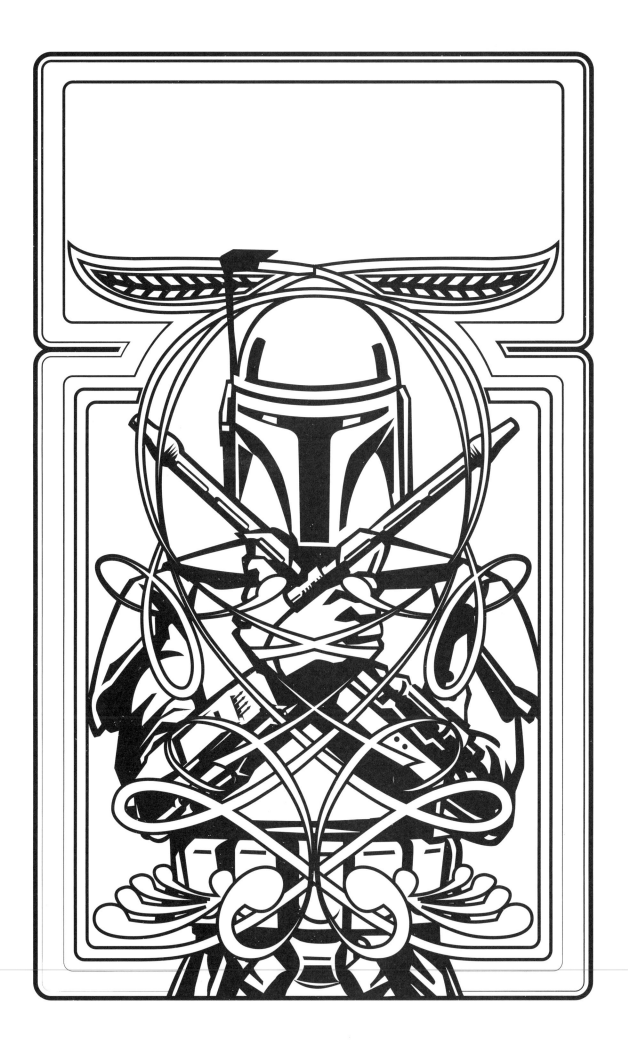

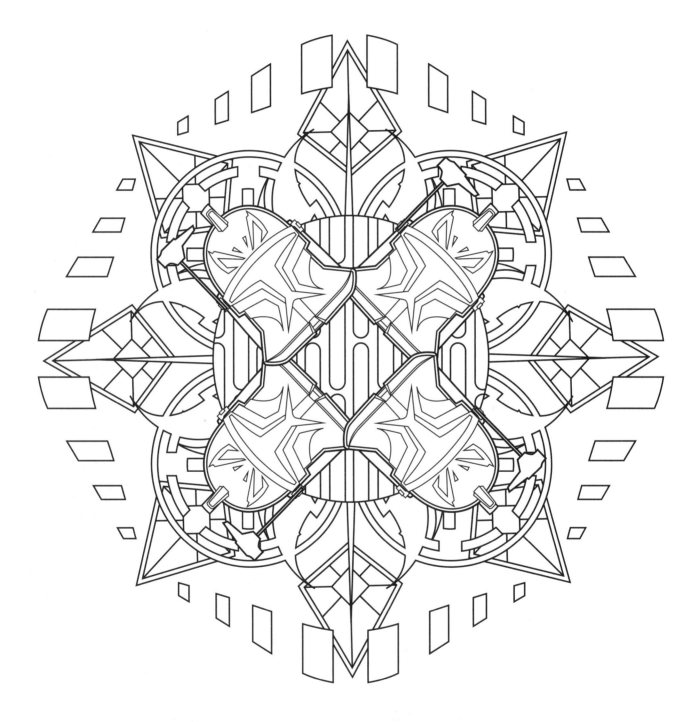

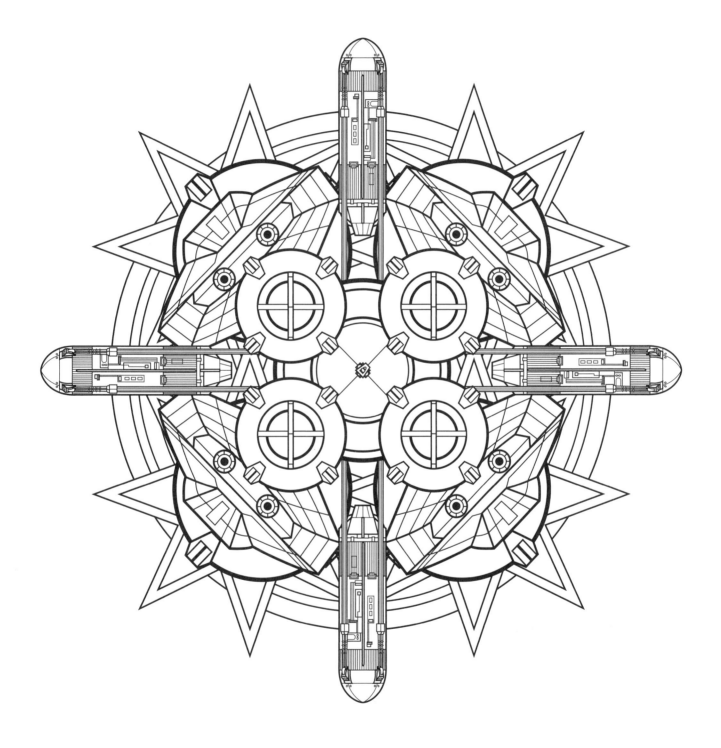

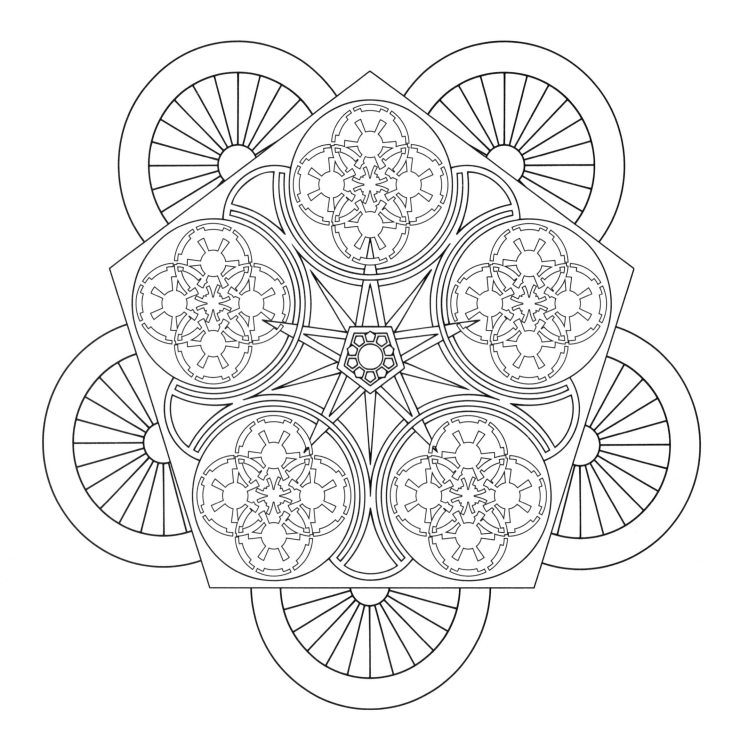

KASHYYYK

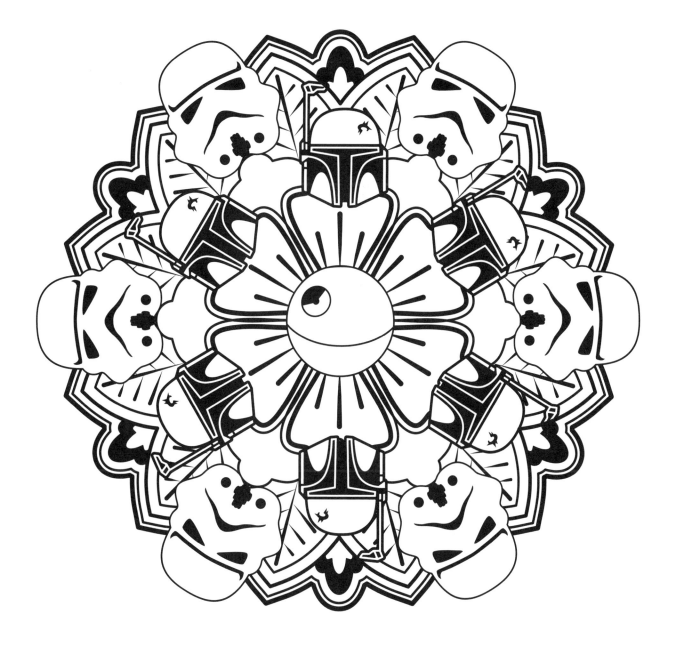

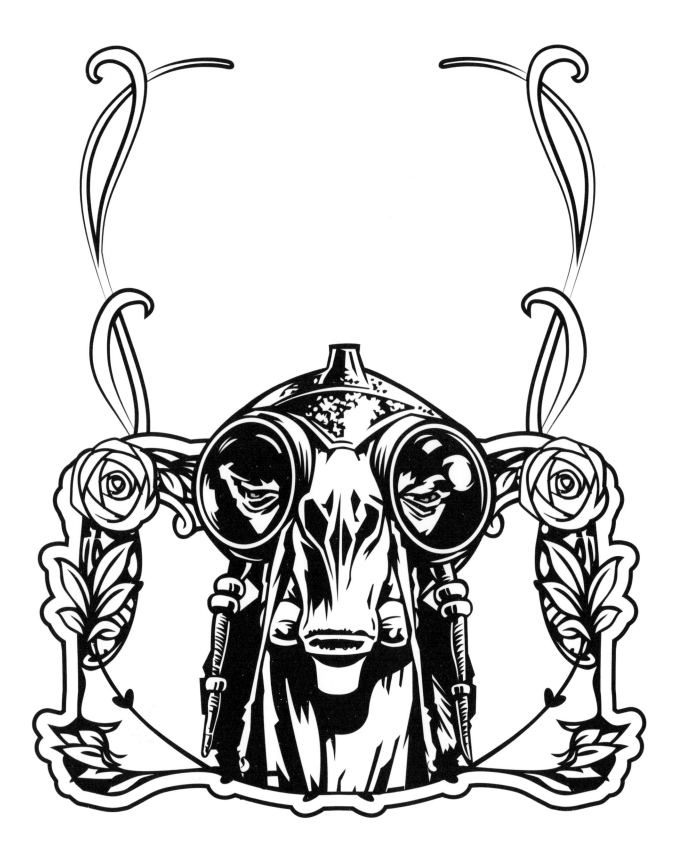

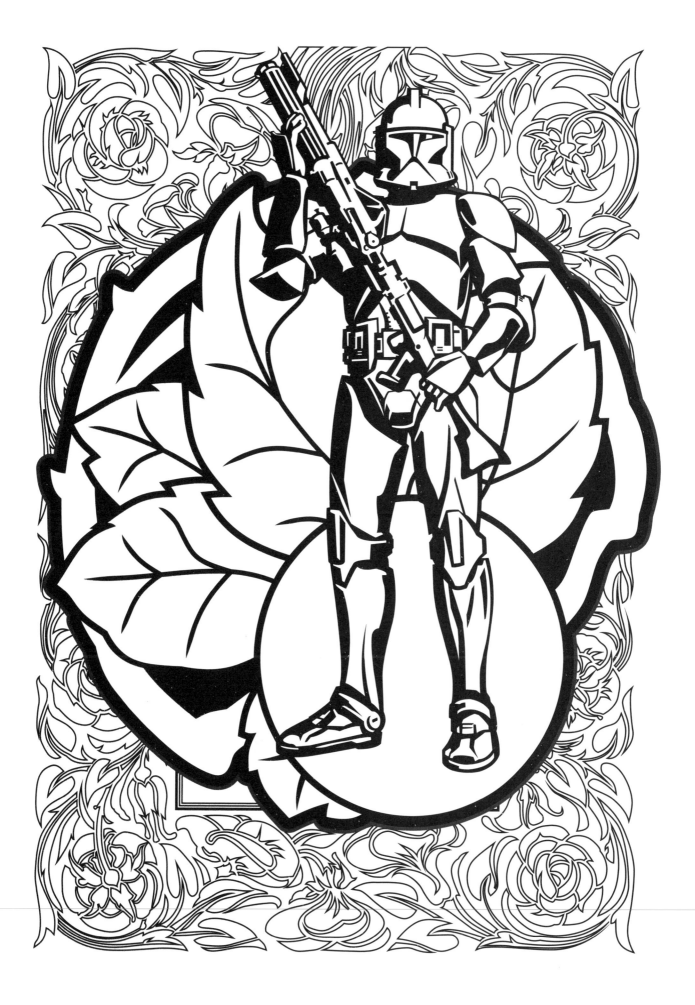

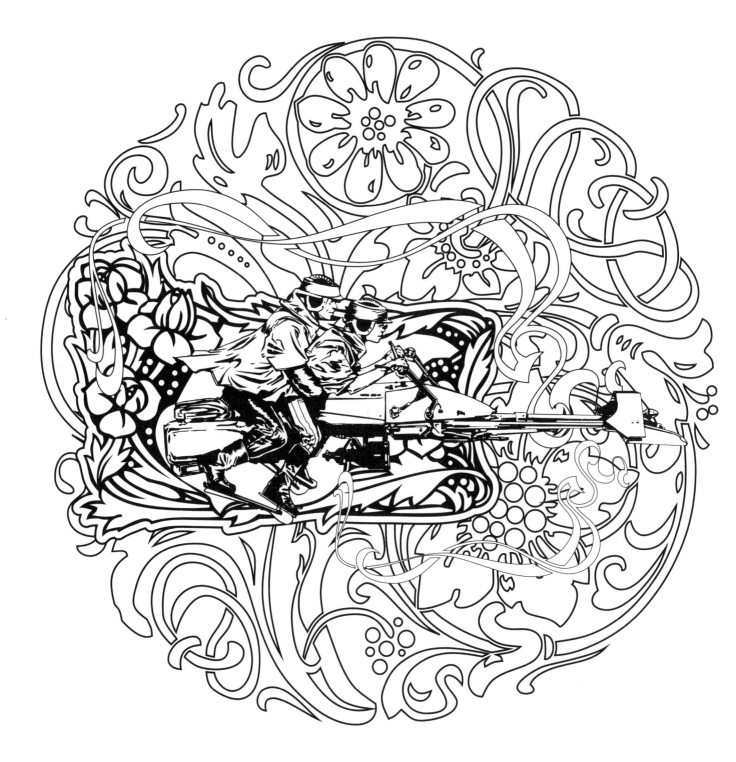

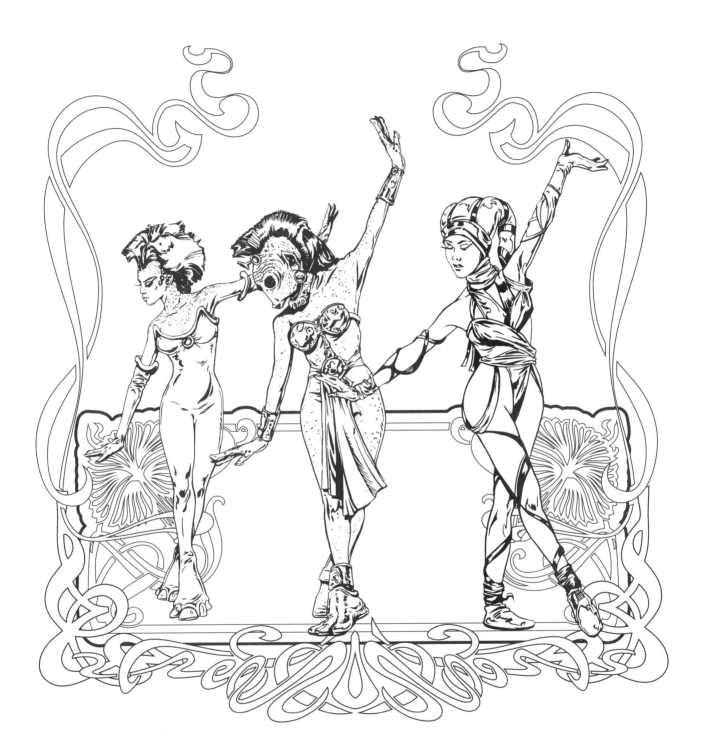

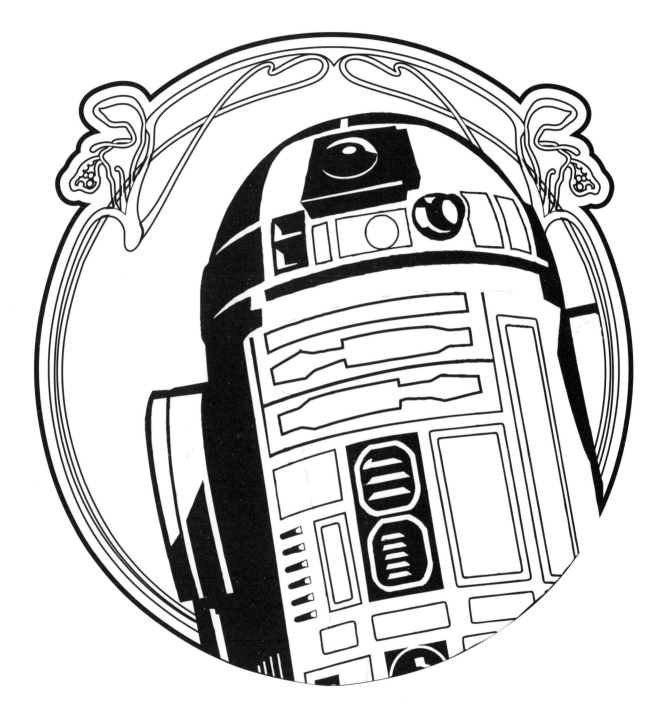

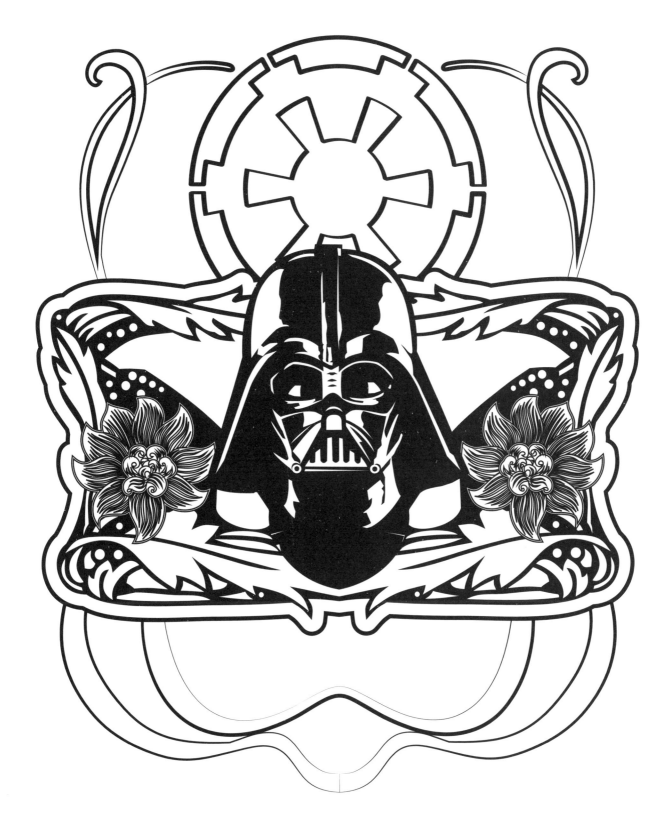

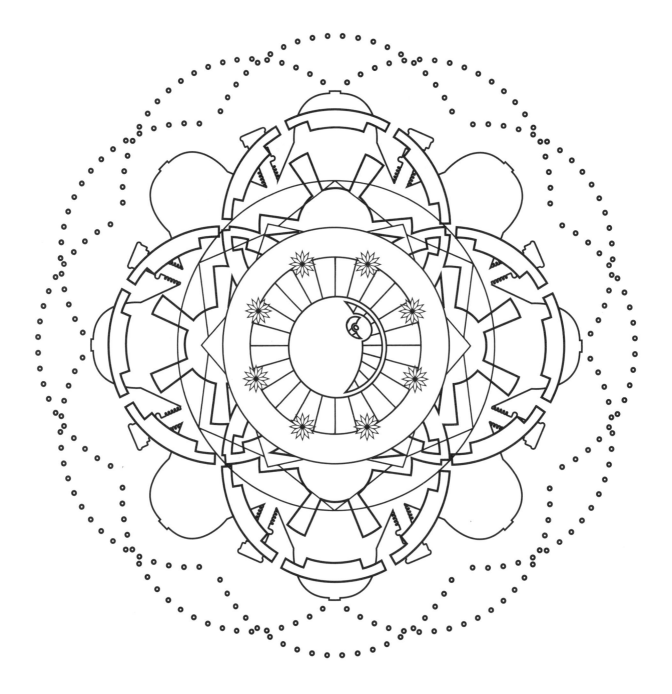

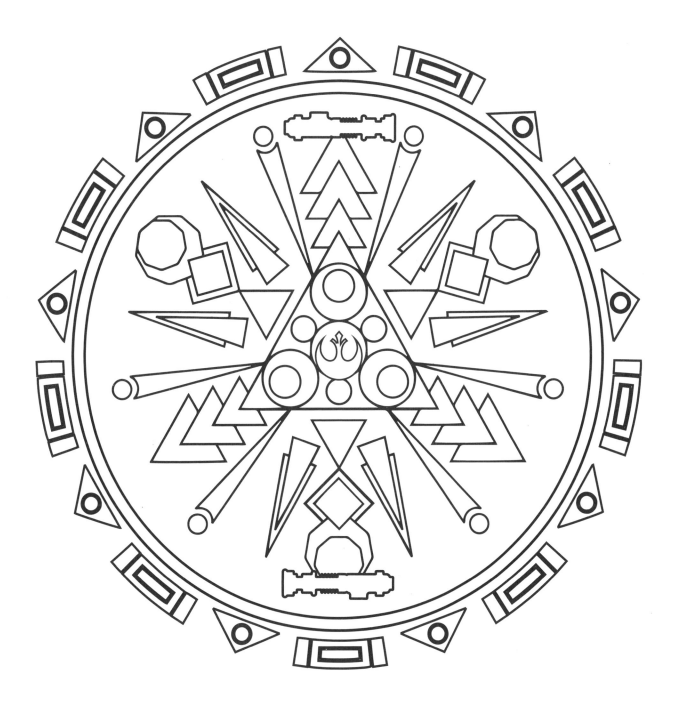

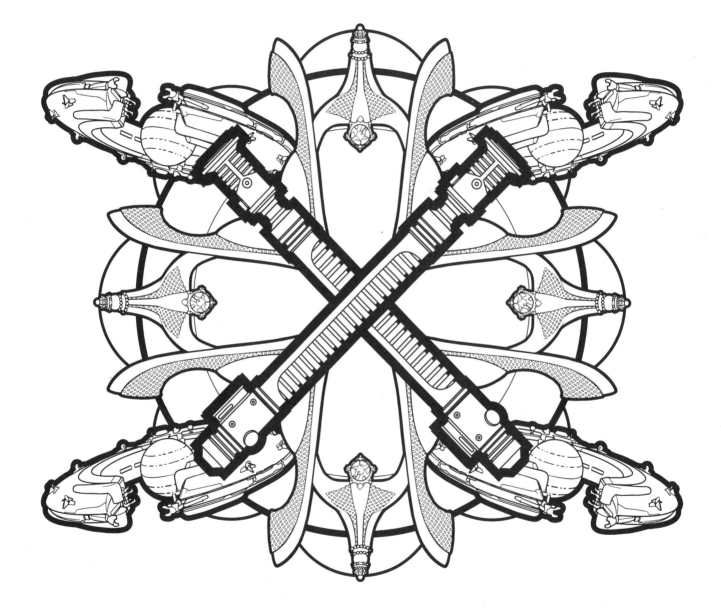

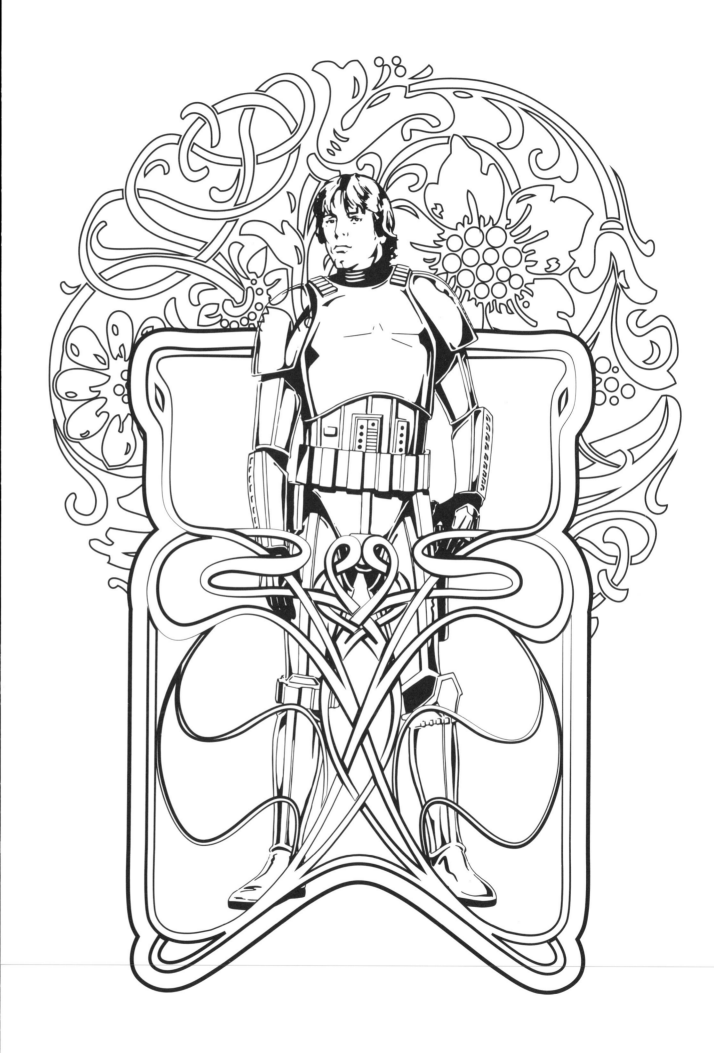

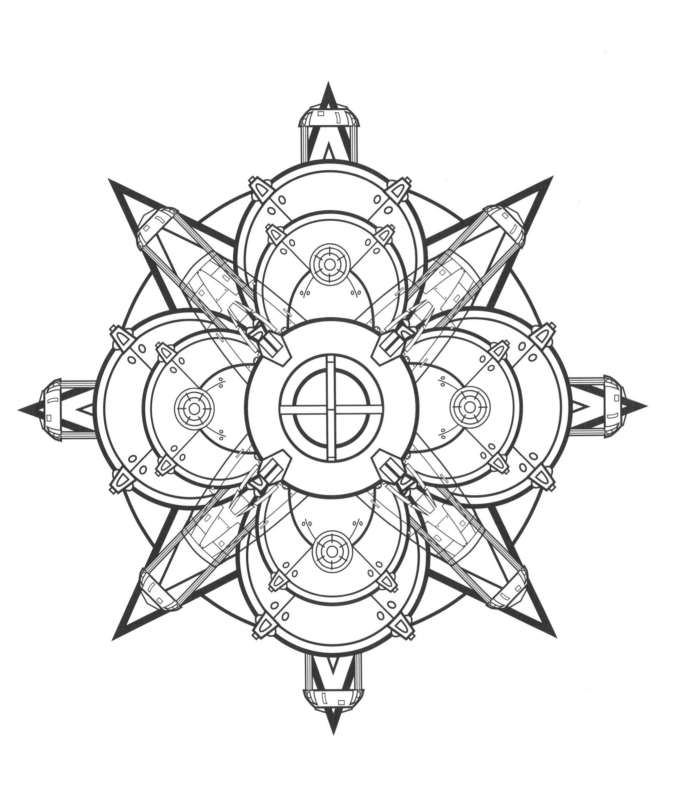

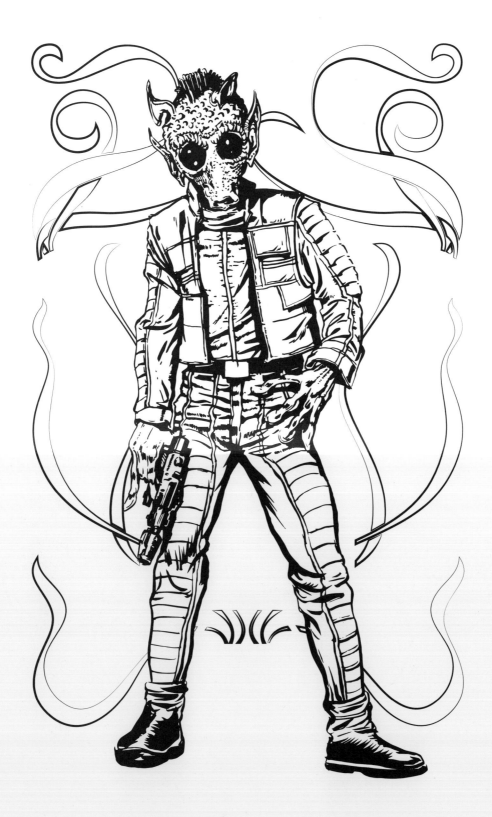

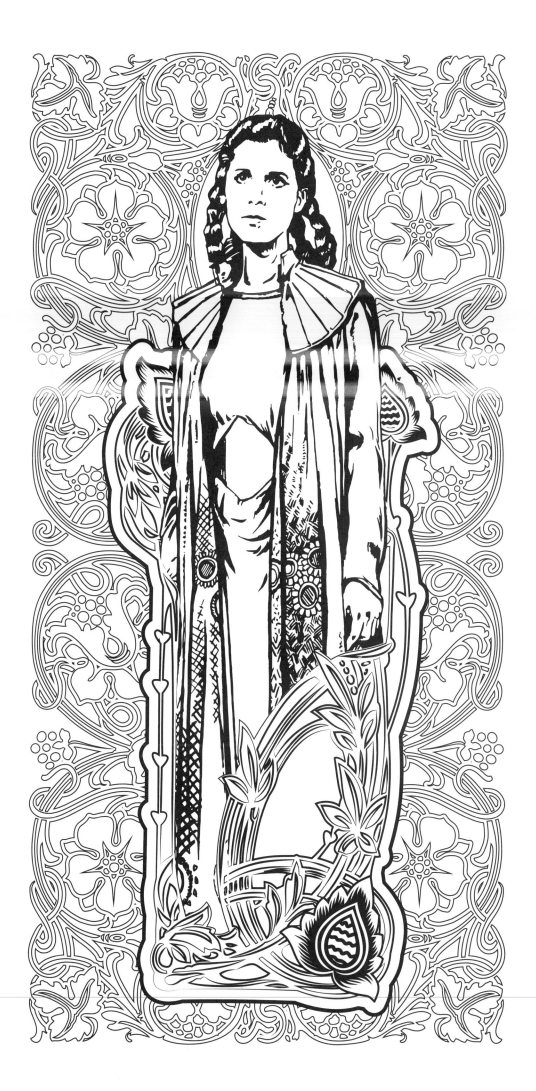

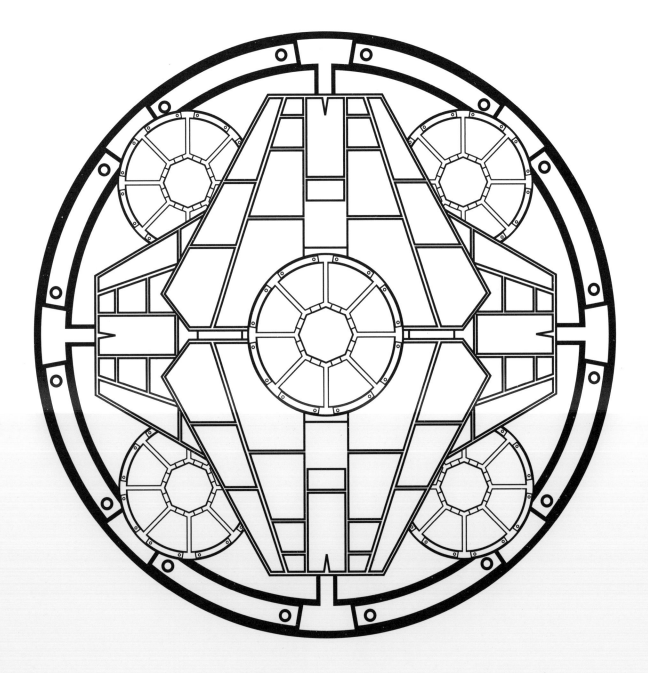

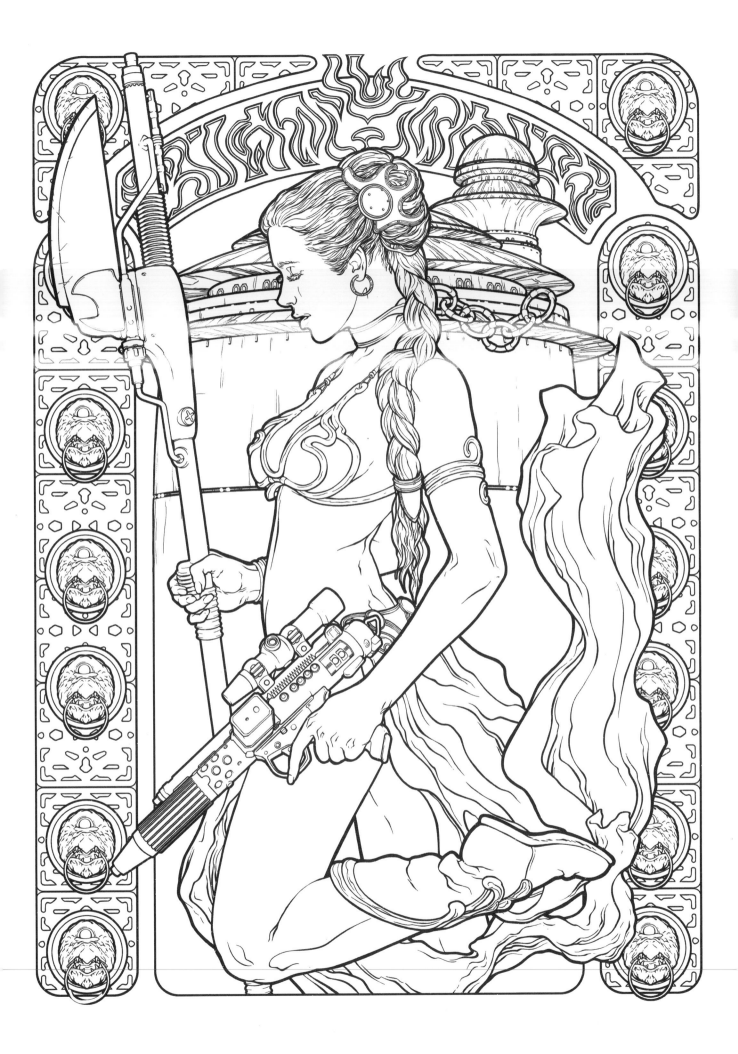

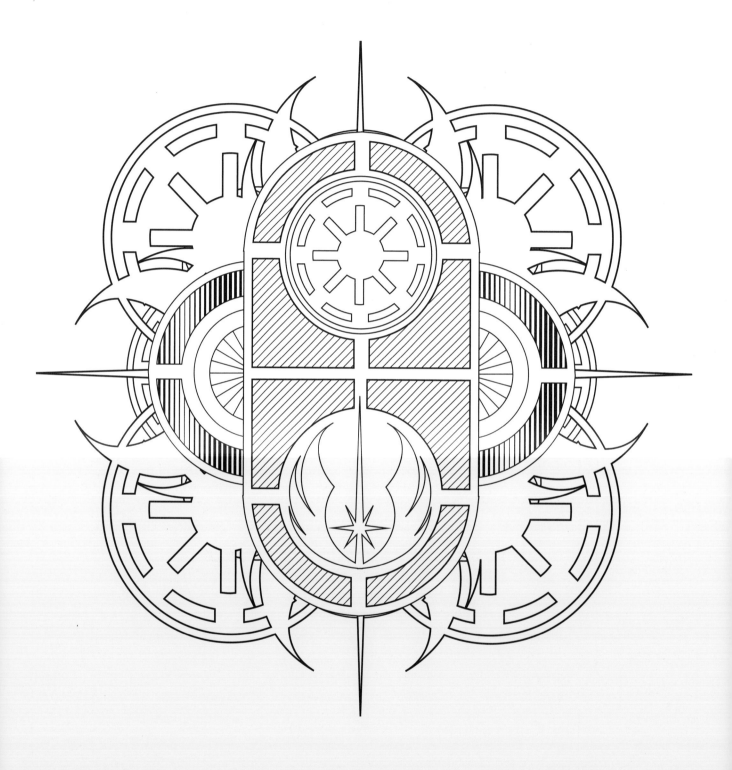

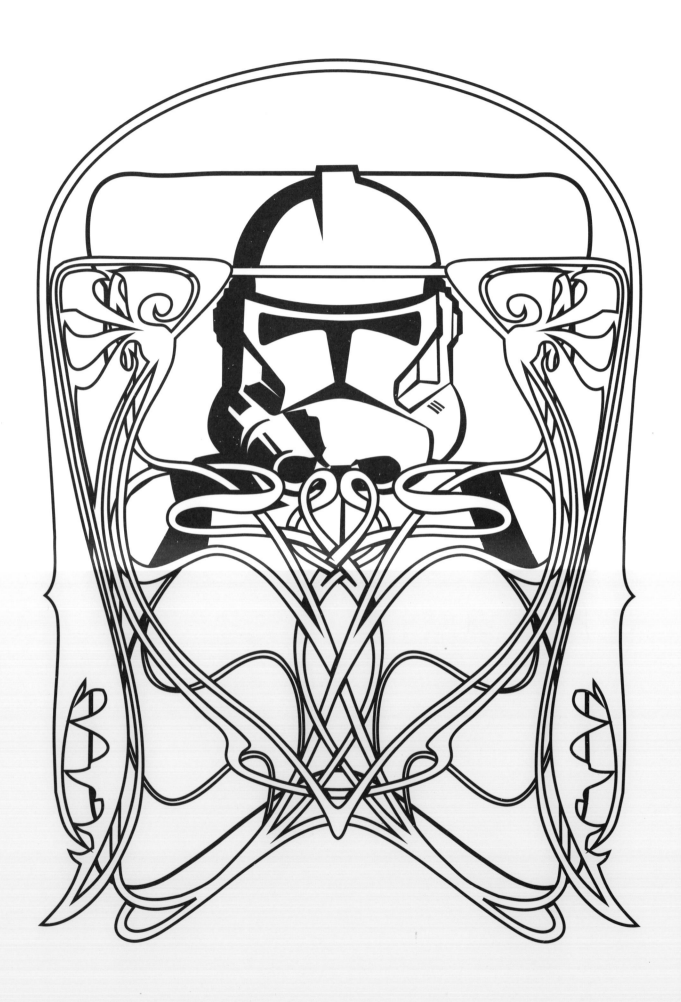

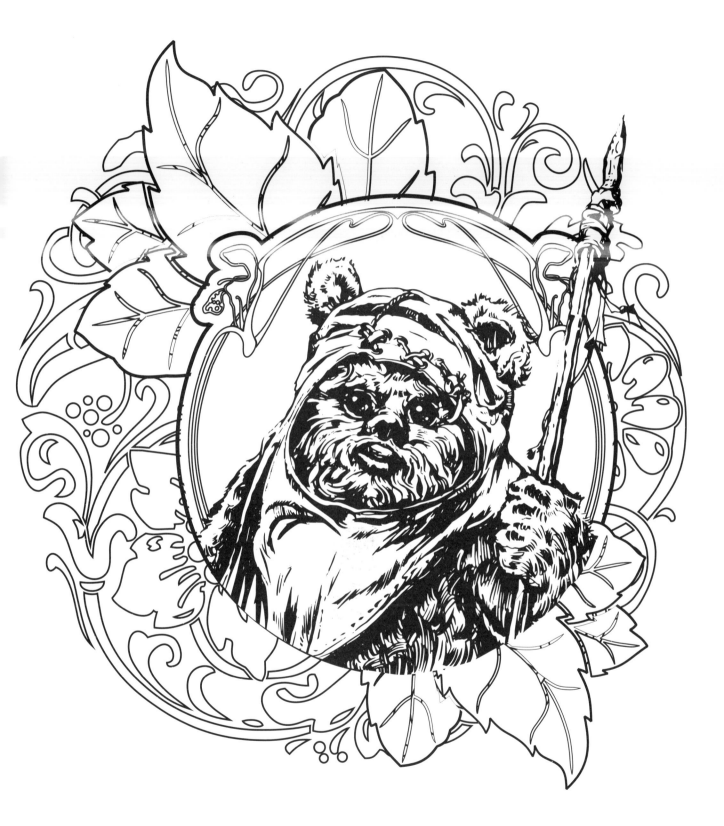

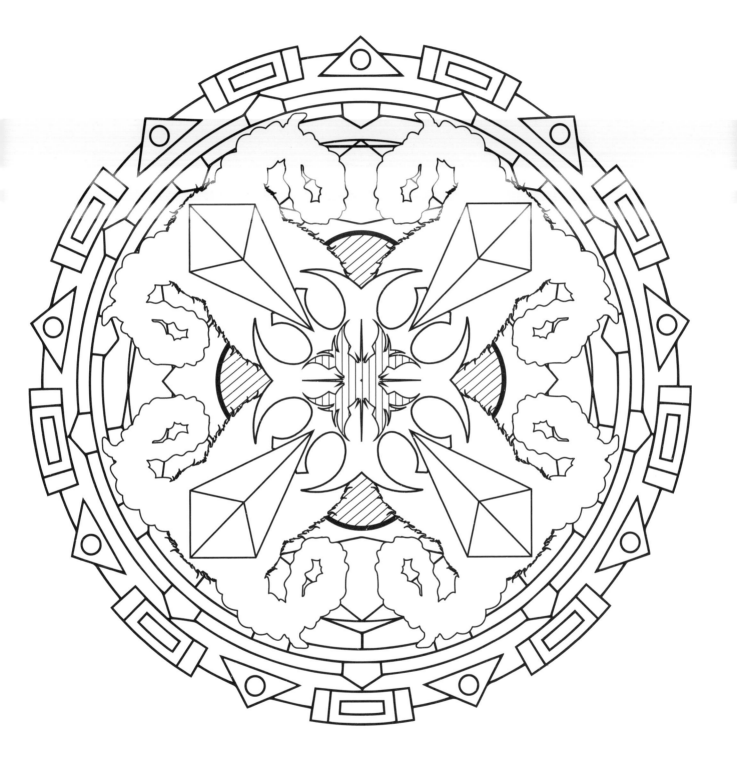

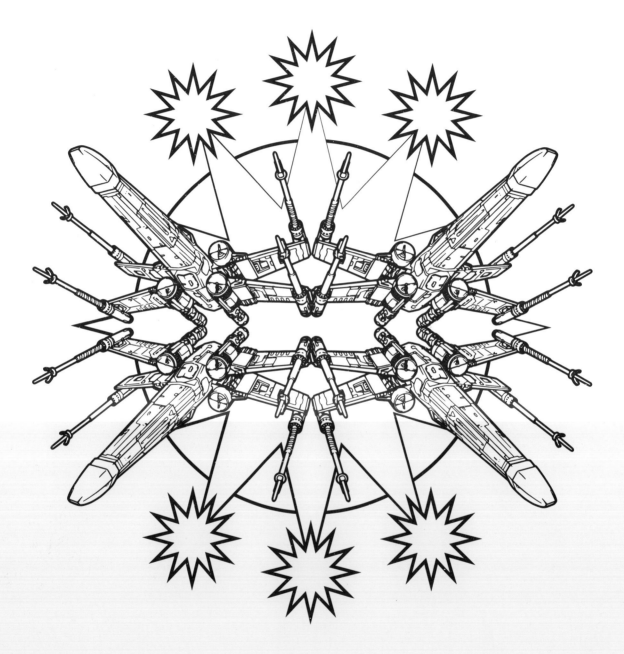

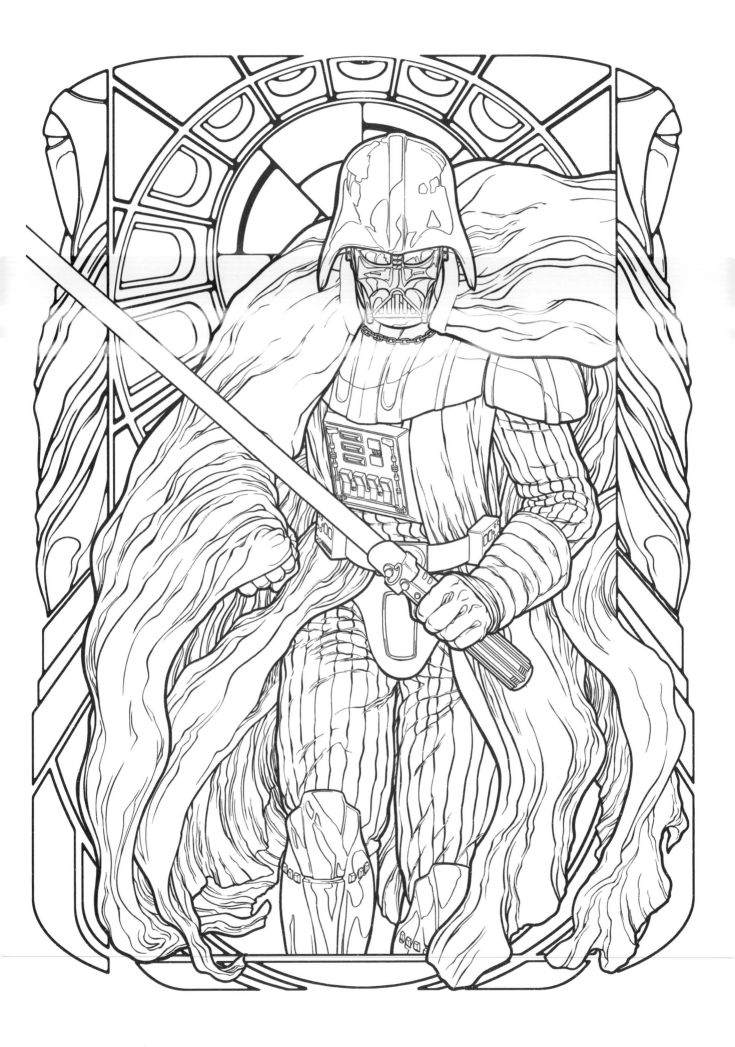

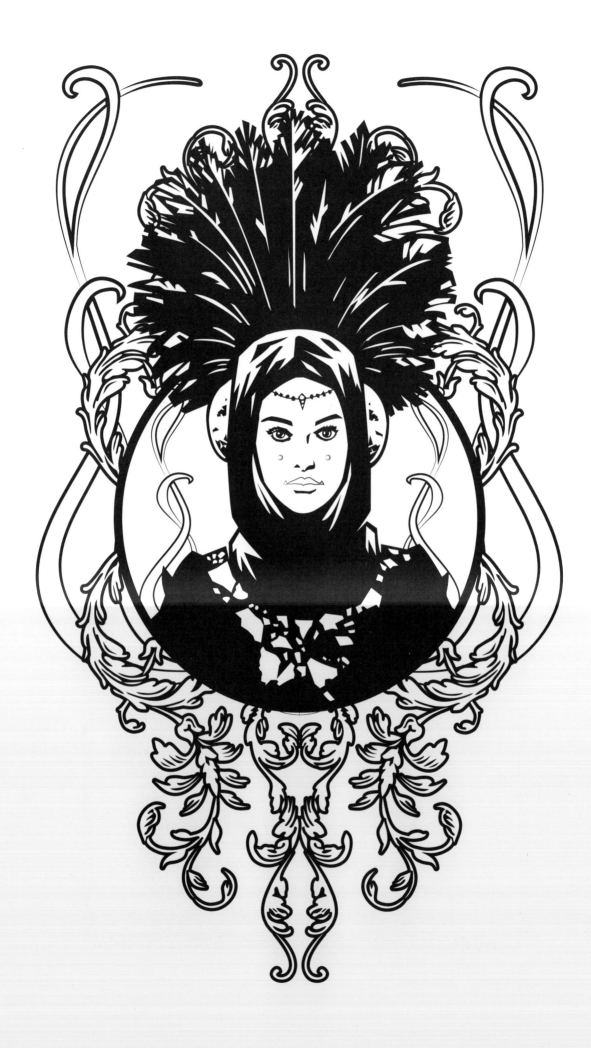

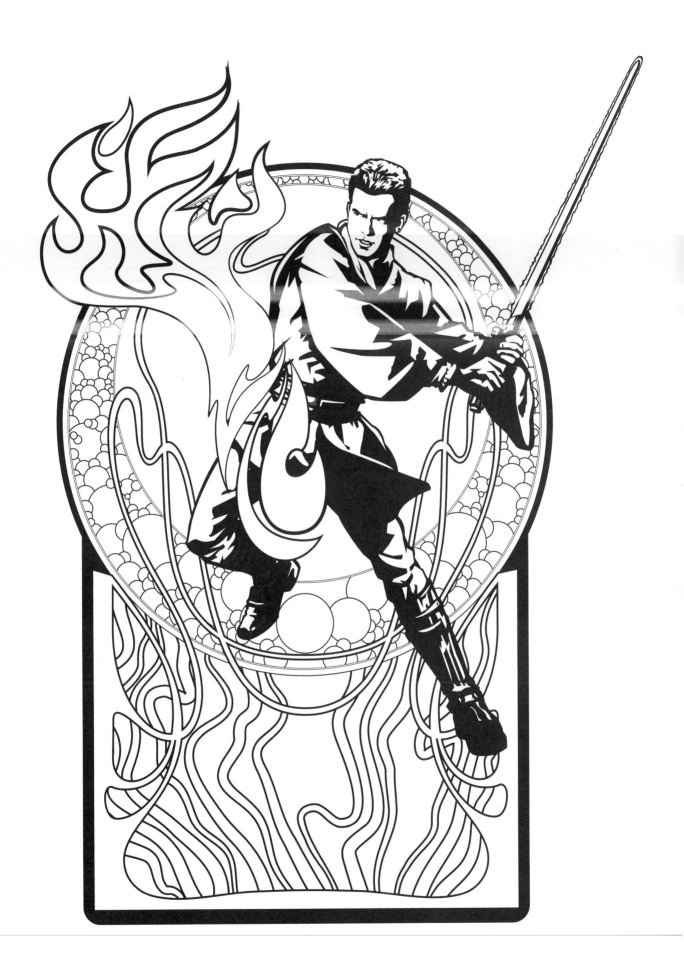

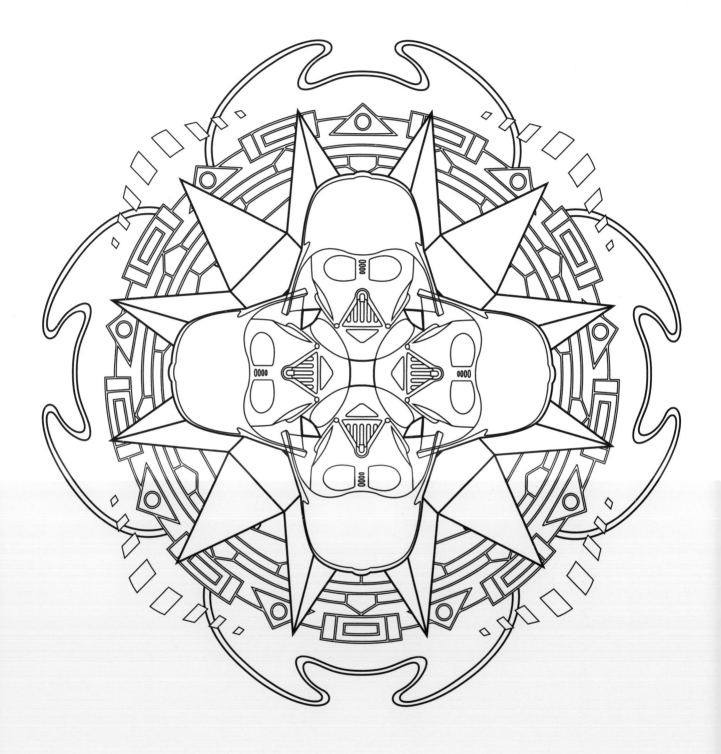

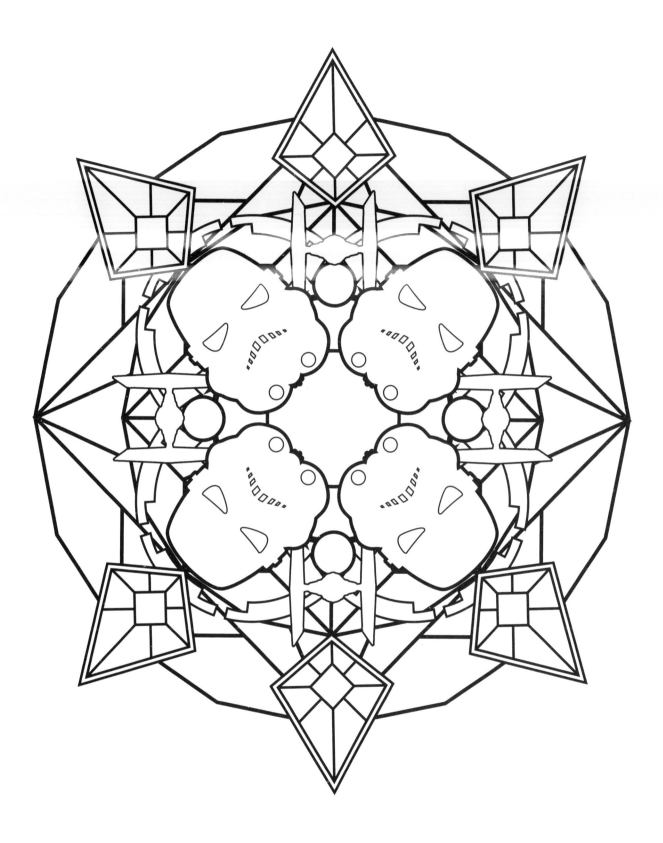

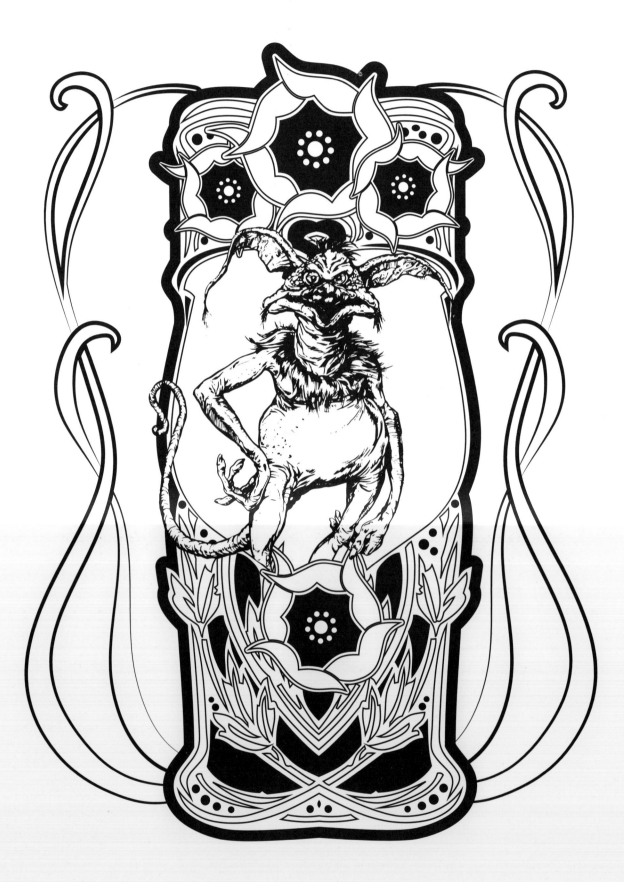

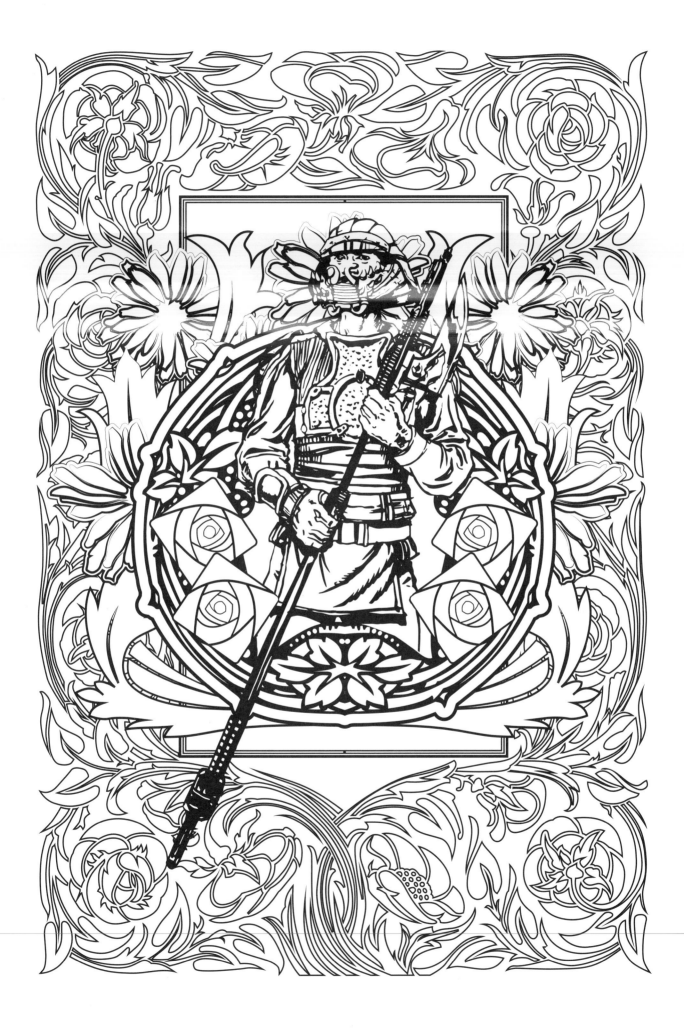

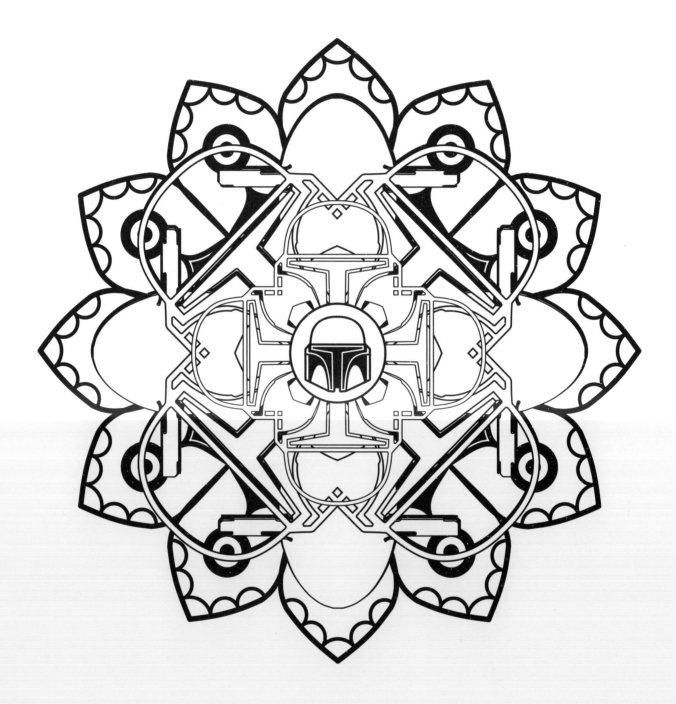

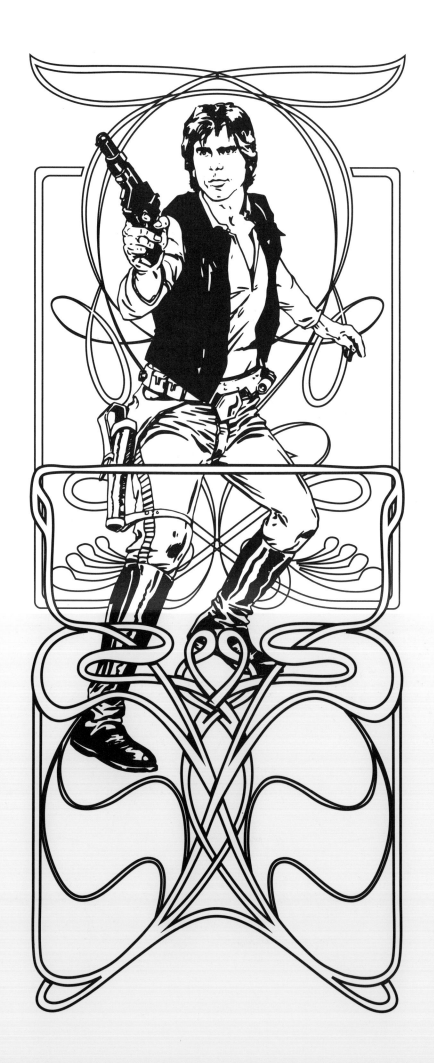

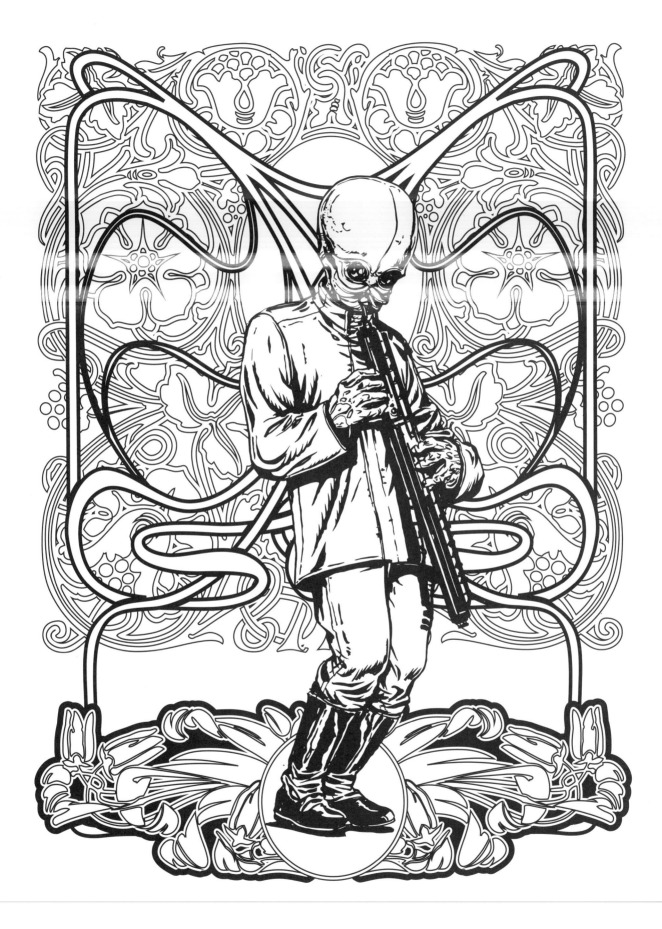

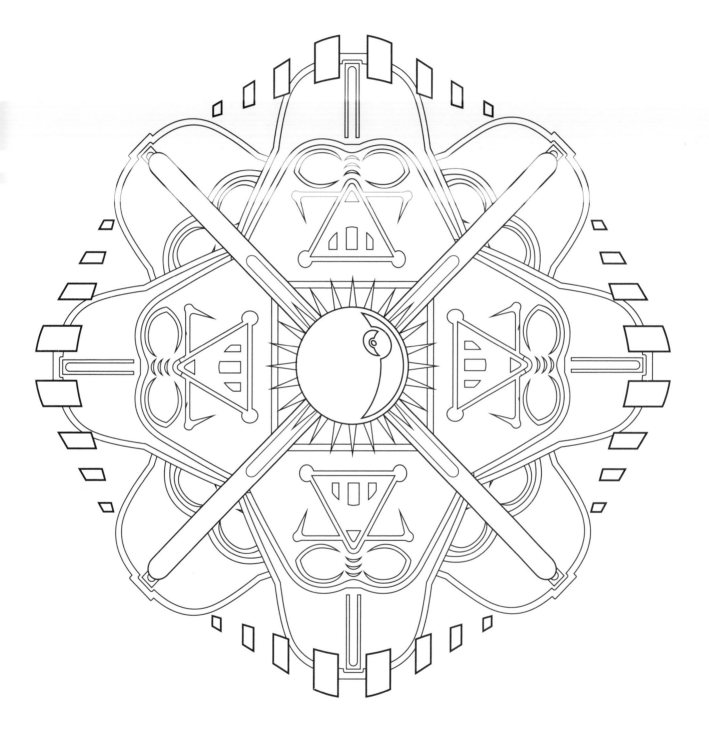

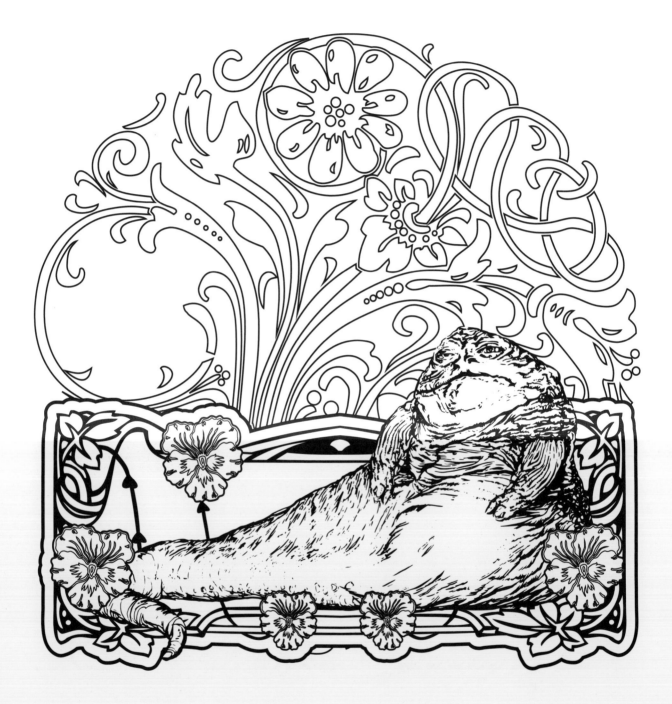

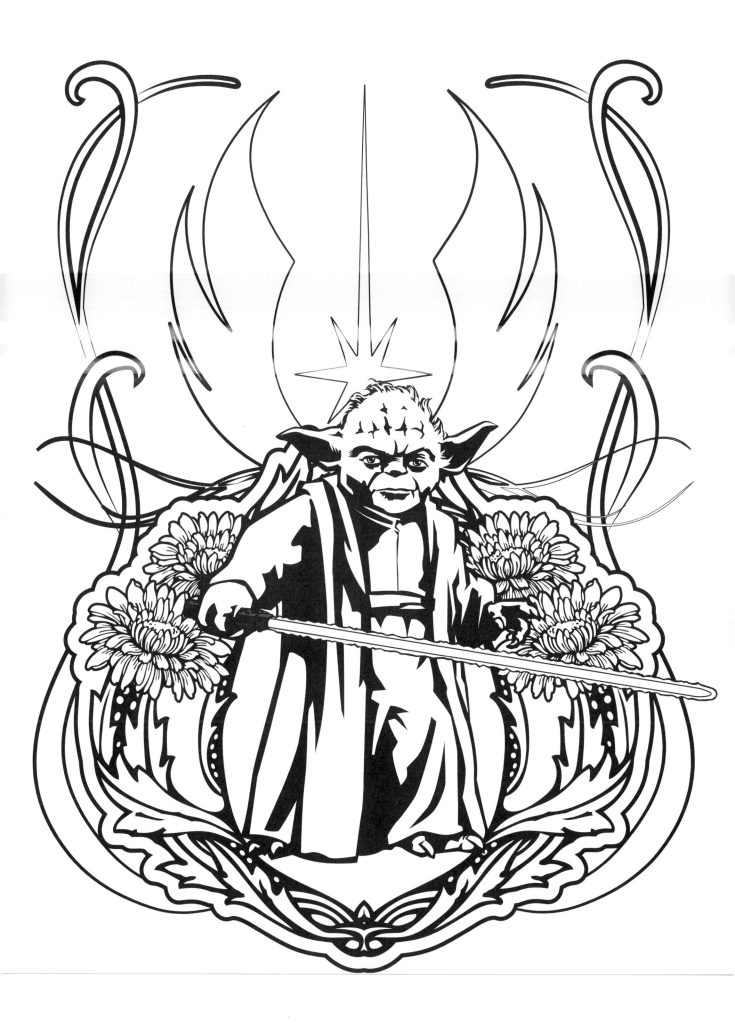

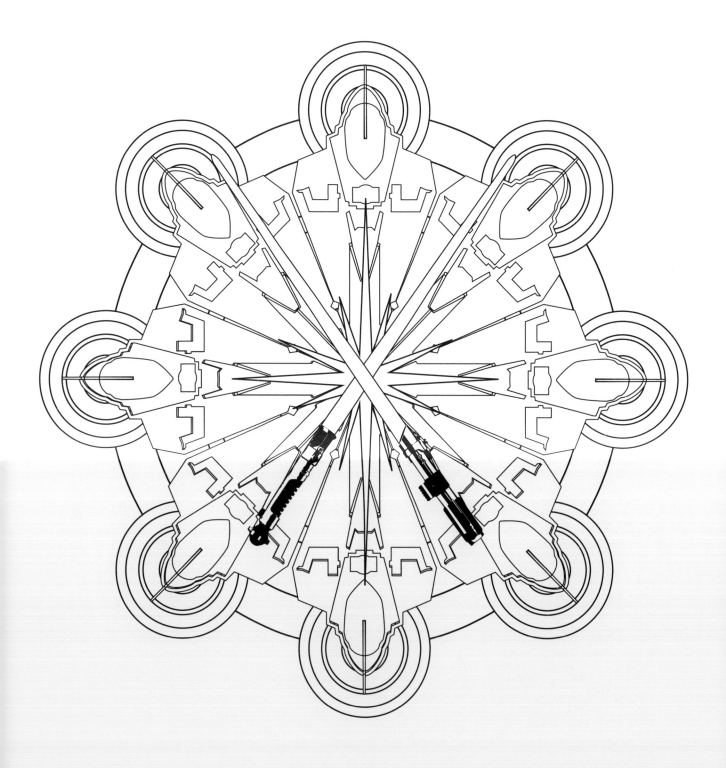

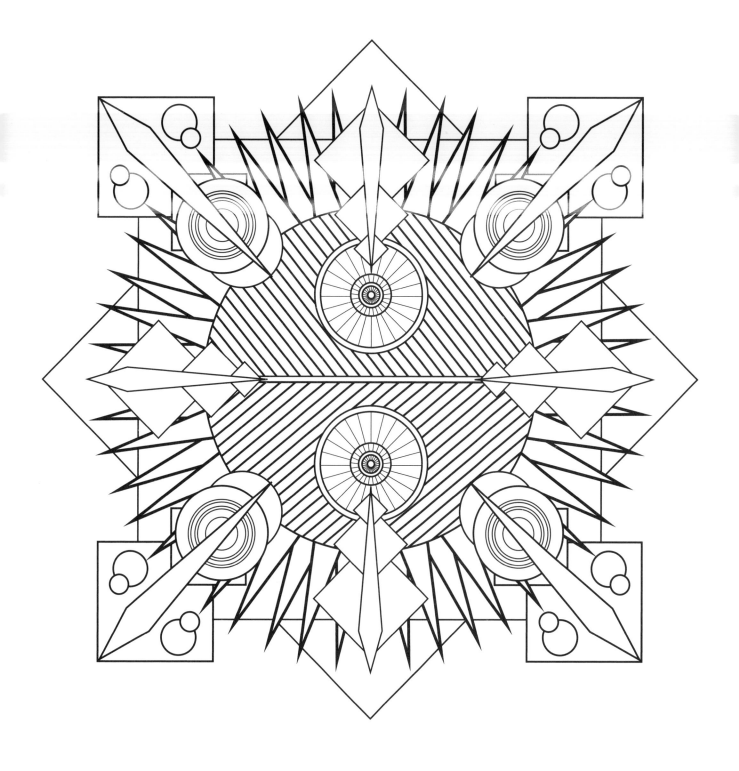

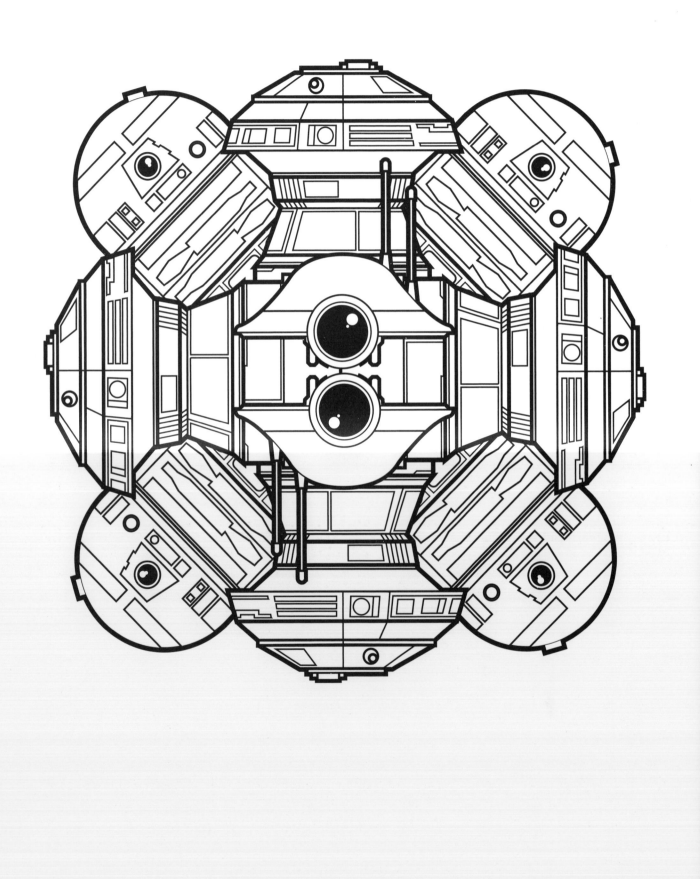

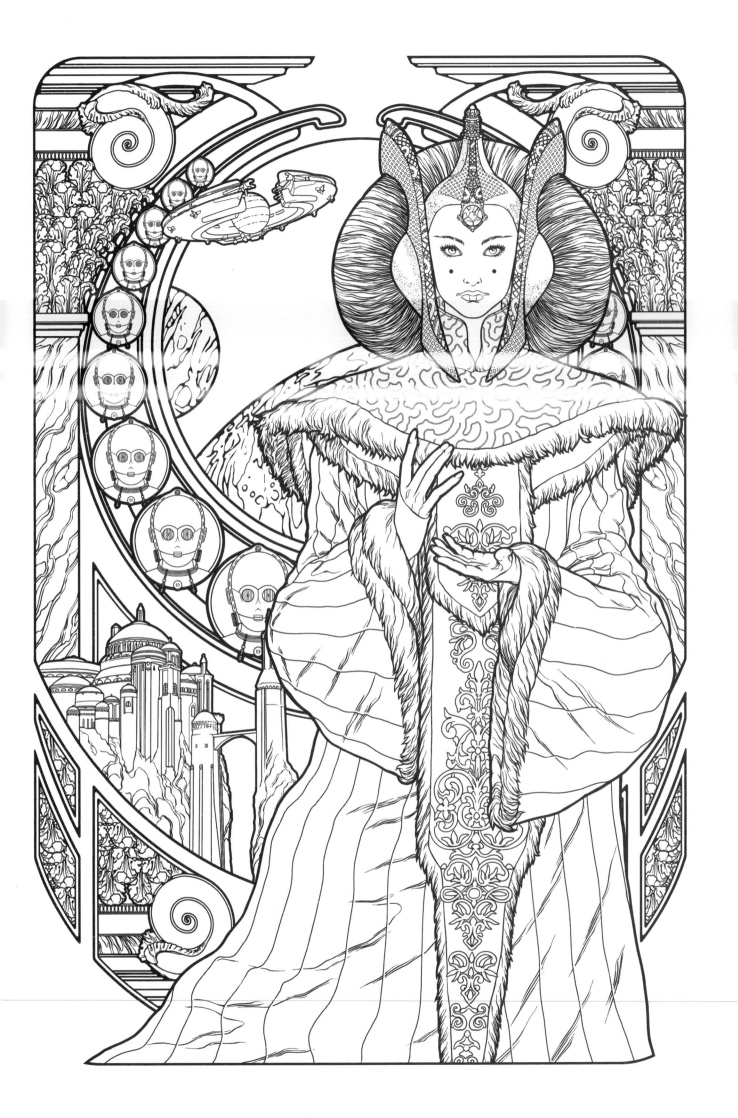

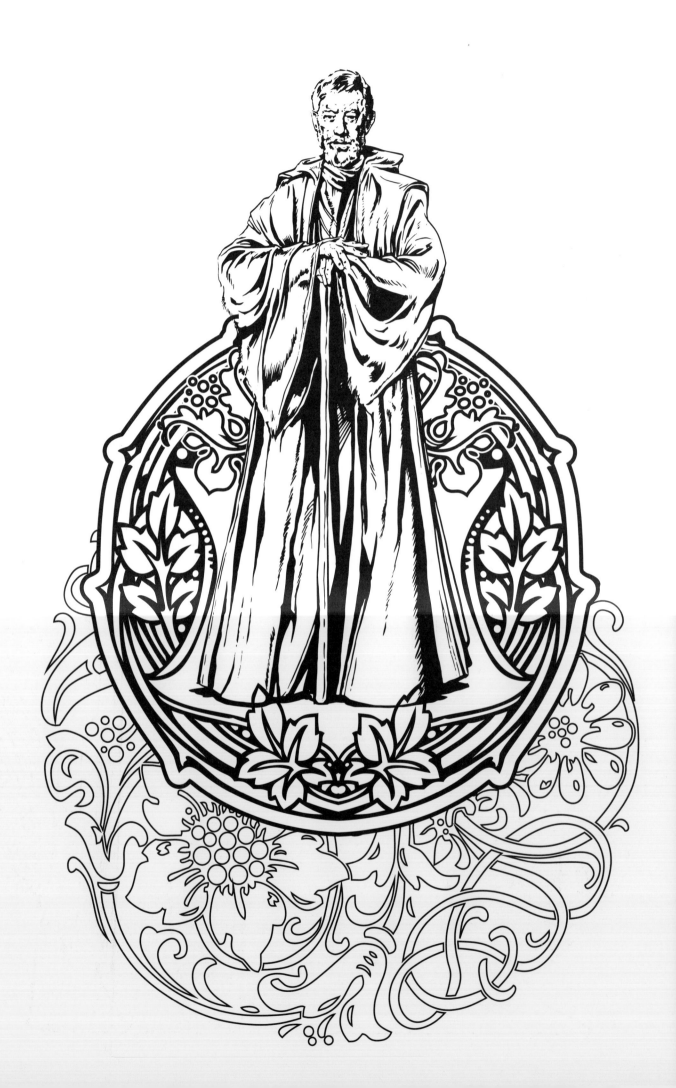

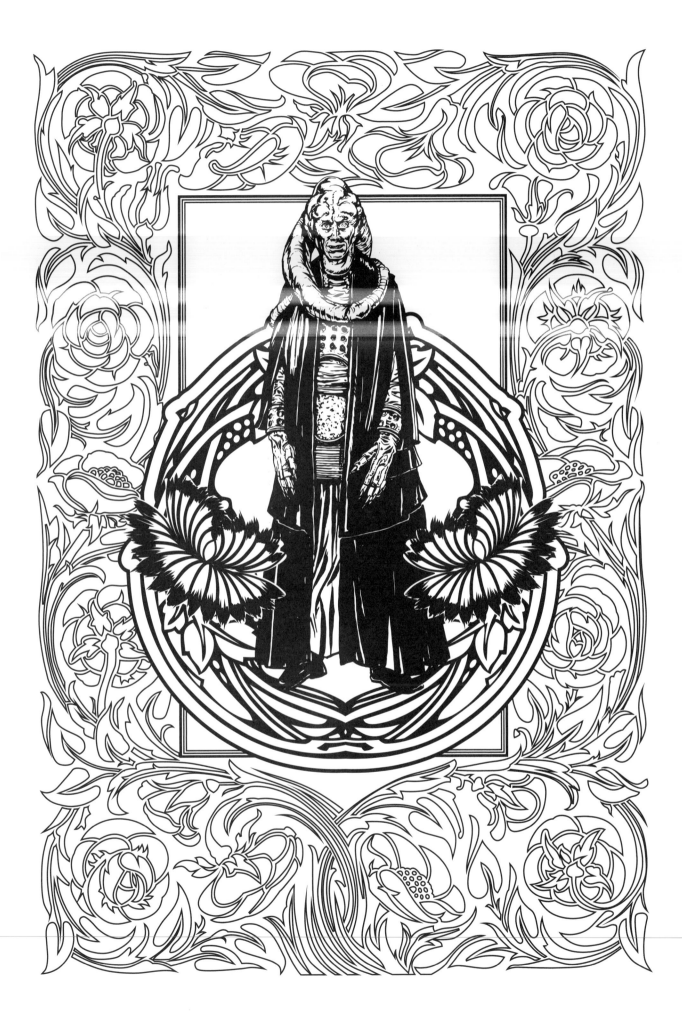

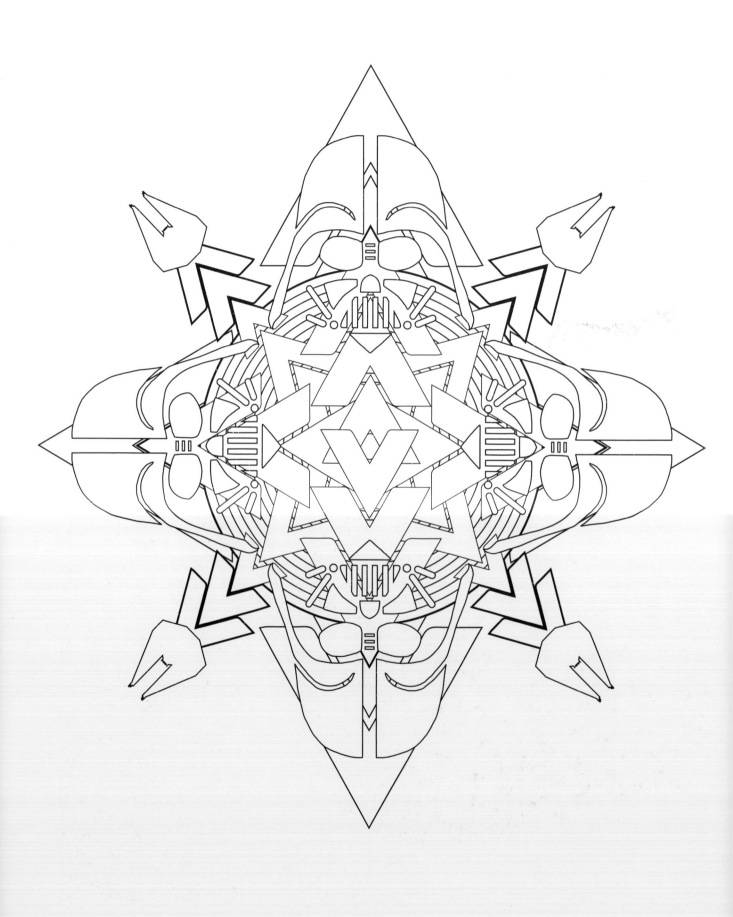

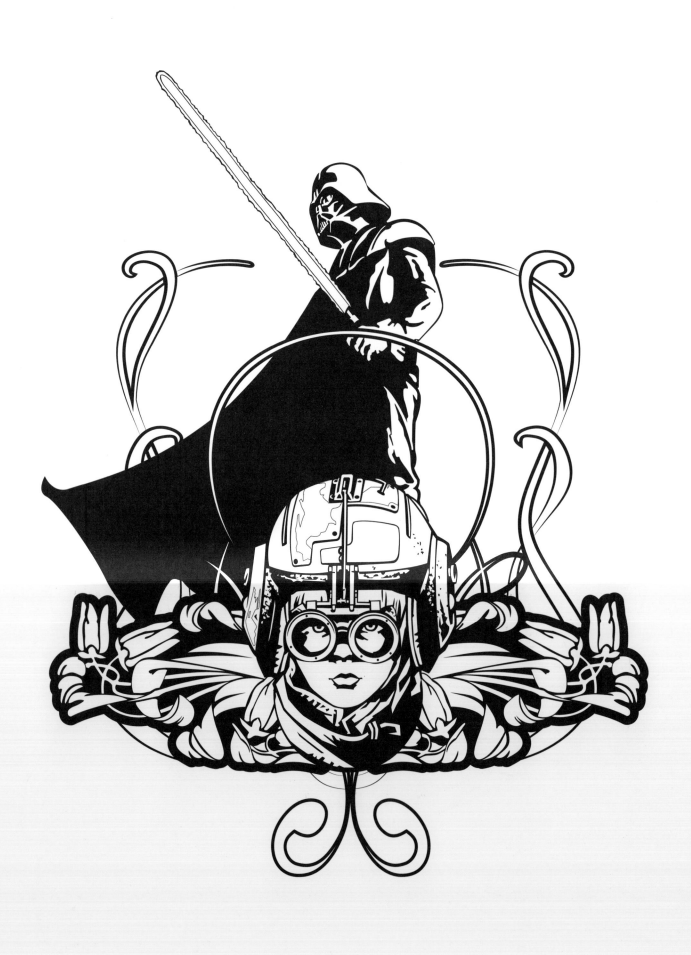

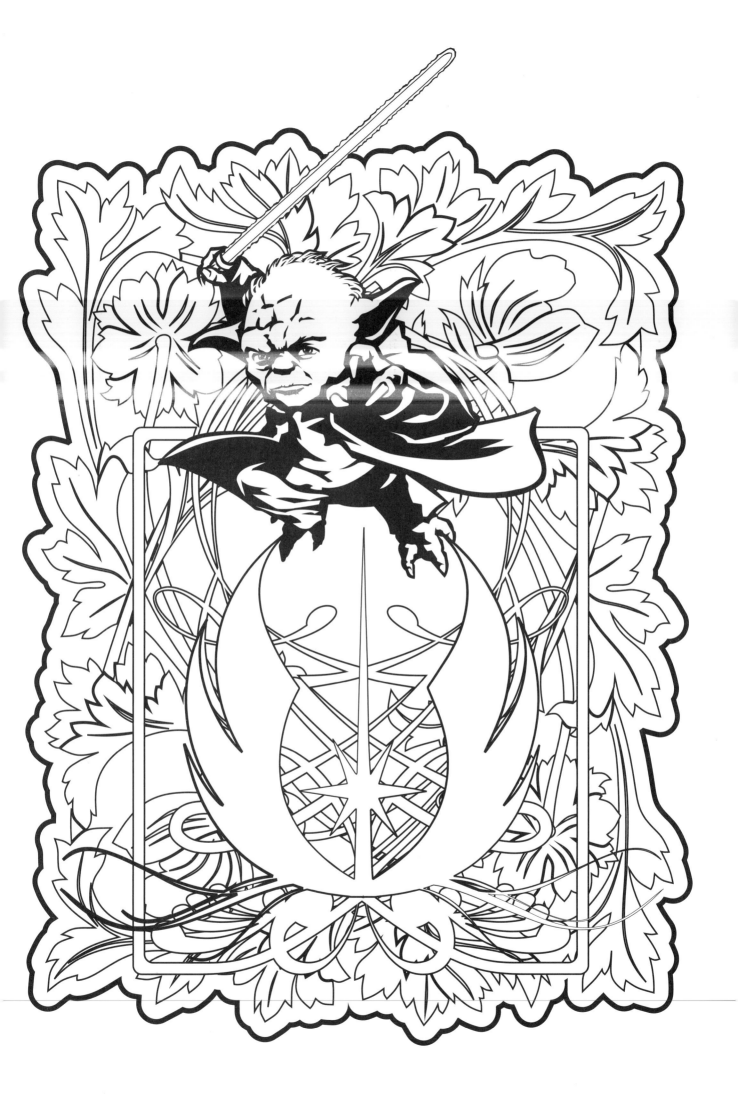

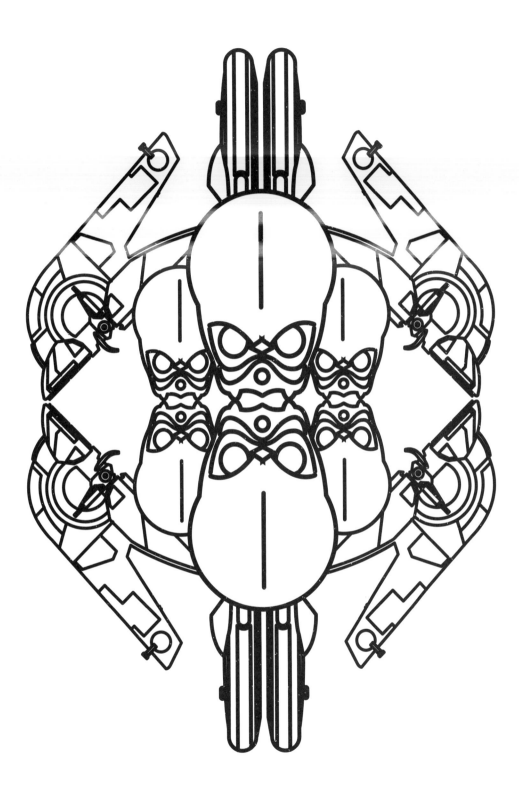

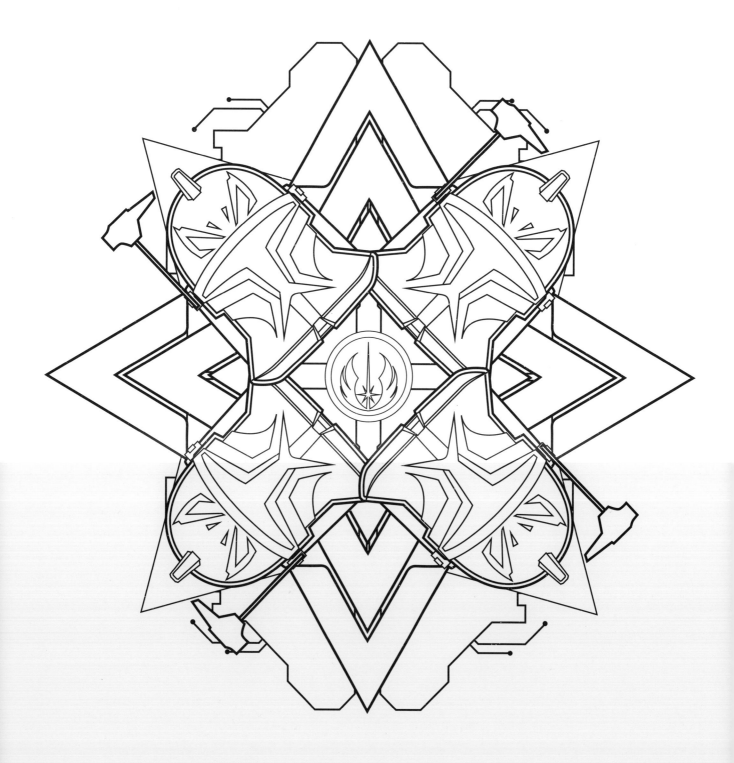